On the Edge of Magic

On the Edge of Magic

Petroglyphs and Rock Paintings of the Ancient Southwest

By Salvatore Mancini

Introduction by Polly Schaafsma

Foreword by Eugenia Parry Janis

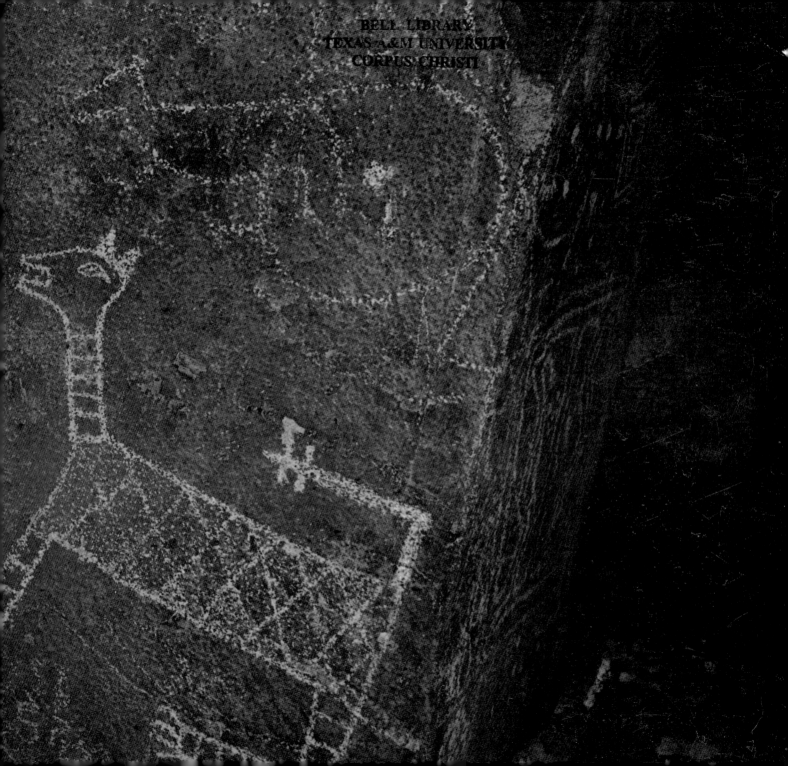

Printed in Hong Kong.

Mancini, Salvatore.
On the edge of magic : petroglyphs and rock paintings of the ancient
Southwest / photographs by Salvatore Mancini : introduction by Polly
Schaafsma : Foreword by Eugenia Parry Janis.
p. cm.

ISBN 0-8118-1167-0
1. Indians of North America--Southwest, New--Antiquities
2. Petroglyphs--Southwest, New. 3. Rock paintings--Southwest, New.
4. Indian poetry--Southwest, New--Translations into English.
5. Indian mythology--Southwest, New. I. Title.
E78.S7M25 1996
709' 01' 130979--dc20 95-21419
 CIP

Cover and Book Design by Pete Friedrich / Friedrich Design

Distributed in Canada by Raincoast Books,
8680 Cambie Street
Vancouver, B.C., V6P 6M9

10 9 8 7 6 5 4 3 2 1

Chronicle Books
275 Fifth Sreet
San Francisco, CA 94103

Title Page A Jornada-style mountain lion with a rattlesnake tail dominates other
Jornada Mogollon petroglyphs on a large section of a rocky outcrop.
1050-1400. Three Rivers, New Mexico.

FOR MY GRANDMOTHER ANGELINA DESIMONE.
THE PETROGLYPHS HELP ME REMEMBER HER.

ACKNOWLEDGMENTS

Many ranchers, cowboys, wayfarers, motorists, geologists, scholars, journalists, curators, park rangers, and gate keepers aided me in making this work. If I have forgotten their names, I have not forgotten their kindness. Some deserve special mention: Polly and Curt Schaafsma freely shared their expertise; Eugenia Parry Janis deepened my artistic appreciation. I was guided by the research of the late Campbell Grant, Harry W. Crosby, Dominique Ballereau, Emmanuel and Ariela Anati, Jim Zintgraff, Professor Solveig A. Turpin, and aided on site by Joseph and Cathy Labadie, Eldon Coleman, Emmitt "Pancho" Brotherton, Benjamin Celaya Crespo, Ramon of Guadalupe, the Chiltons, Dr. J. Eldon Dorman, the late Tina Depuy, Paul Taylor, Jeannine Nelson, Roger and Darlene Nichols, Patrick Foott, Eric Bengtson, Cory Dezelsky, Jack Skiles, and William McFarland. My patrons Vincent and Linda Buonanno, Diane L. and Duncan Johnson, Maria and the late Irwin Rector, John Rector, and Teresa Level gave precious funds and friendship. Additional funds came from the Rhode Island Committee for the Humanities, the Rhode Island State Council on the Arts, and the Polaroid Corporation. For American exhibitions of these photographs, I thank Barbara Hail and the Haffenreffer Museum of Anthropology, Brown University, Diana Fane, Barbara Millstein, the Brooklyn Museum, and Fernando and Michela Garzoni. In Italy, my thanks go to Luca Darbi, World Action Project (Verona), Baldassare Conticello, Soprintendenza Archeologica di Pompei, and the Meeting Per L'Amicizia Fra I Popoli (Rimini). The late Paul Krot gave valuable technical assistance, the late Aaron Siskind inspired me by his example. Randi Savoy, Don D'Antuono, Patricia Childers, Richard Scorpio, Mary Vanelli, David and Carol Robinson, Mario Samarughi, and the Soscia family gave precious encouragement, as did my long-suffering family: my parents, Maria and the late Antonio Mancini, Susan and Chris Nichols, Sara and Redband Judge. Anthony Russo showed me my first petroglyph, I haven't forgotten.

Salvatore Mancini

CONTENTS

PREFACE

I discovered the rock art of the Anasazi and other Indians of the Southwest in 1986. Sacred places have always attracted me, and only after traveling through the region for the fifth time did I happen to discover the existence of these ancient drawings as I leafed through a national parks brochure. Soon I was ordering books to learn where these drawings were. As with my other photographic expeditions, I became obsessed. Certain petroglyphs were easy to find, but I preferred to move through lands where the terrain and climate could surprise me. I located sites by following tips from a range of sources. With these leads I crossed plains and river basins, seeking cloistered washes and arroyos that opened up into petroglyph panels at the end of the most indistinct trails. After

hiking all morning through brush and boulders there is something spine-tingling about discovering figures in stone that seem to await my arrival and suggest their powers as if for the first time in millennia.

The stress and strain of finding the petroglyphs forced me to consider nature the way the Indians themselves had done. It is difficult to think of landscapes today without modern highways, but I found myself following what seemed to be the rock artists' "original" roads, and I began to form an entirely new conception of landscape space. This is the key to understanding the role of the drawings, for they seem to connect not to the eye of the viewer but to the animus of the entire terrain. Because I wanted to walk the distances to achieve an intimacy with the settings and with those who preceded me, I used a 35mm camera. Using the small camera I stood where the ancient artists stood, captured their handwriting in relief on the surface of the stone. It is not my concern to determine the precise meaning of the art. To me the images suggest myths. I know that the Indians are showing yet another conception of the universe, another cosmology.

I view the drawings also as records of past lives. In photographing I enter into communion with these ancient inscribers. My life overlaps theirs as I stand before the stones and stare at the masks, warriors, star beings, and snakes that stare back at me. In making the shadow of my hand correspond to an ancient hand cut into rock, I relive the experience of people trying to make sense of their world as I try to do with mine. My photographs, like the drawings, are also tracings that continue to relate the history and cosmologies of the ancients. With my camera I release the petroglyphs from their sites for the rest of the

world. Photographing them, I'm a modern man trying to renew himself in terms of the ancient past. Out in the landscape, shivering in my own sweat from the cold or exhaustion, I find I can revive a lost connection to an older world, a more fundamental understanding of the relations between things. My love for these images lies in the fact that, rather than reveal their true histories, they include me and allow me to respond intuitively to the immense force of their presence.

Salvatore Mancini

FOREWORD: POWER LINES

While I stood there I saw more than I can tell and I understood more than I saw;
for I was seeing in a sacred manner the shapes of all things in the spirit, and the shape of
all shapes as they must live together like one being. . . . And I saw that it was holy.

Black Elk

t is consoling to sit in certain landscapes of the American West where vastness still
overwhelms human interference, and to absorb the silence, broken only by a crow's
wings rasping rhythmically in flight like coarse silk against the wind. To wander
in such spaces, and to stumble upon an ancient petroglyph, is wonderful. Each
revelation is a mysterious gift. But the discovery raises questions about our ability to read these drawings
as well as to value and protect them.

A hand, a grimacing mask, carved or painted on a stone or rock face, a human figure
with the head of a duck or surrounded by force lines, declare that what we now call wilderness was once a

homeland, a hunting ground, or a site of transcendent ritual worship. To understand ancient markings in these contexts requires a relationship to them for which there are few good models in present-day visual culture.

Everywhere the presentation of pictorial art is one of boxing in. Not only the television screen but the four lines of a canvas reduce appearances to a predetermined field; the walls of museums and gallery rooms inflict a similar geometry, and reproduction in books and magazines exacerbates the shrinkage with photographic miniaturization. Even contemporary graffiti artists, avoiding traditional art sites and shouting freedom by scrawling on subway trains or city walls, condemn their markings to repetitious rectangles. Such confinement is unknown in the sacred formats of American Indian people. As the visionary Black Elk lamented when forced to live in a cabin, "There can be no power in a square."

Petroglyphs float in indeterminate spaces delimited only by the natural configurations of the stone or rock face. The feet of warriors, hunters, spirit guides, and animals ignore the solid foundation that much of Western art deems the origin of rational space. This hovering overrides all earthly matters by speaking directly with the spiritual realm. Black Elk recalled, "I thought of my vision and seemed to be lifted clear off the ground." Each figure with arms reaching outward and upward is not a description or character in a narrative but an emblem of ecstatic humanity, literally beside itself. Petroglyph drawings and paintings are linear force fields, the pulsing energy suggesting an eternal interchange with the unknown. Wide-eyed expressions and open-handed gestures are horrific reactions to this realm.

These visions are hardly unfamiliar in the history of art. Christian saints in Byzantine icons hover similarly in ideal celestial spheres that transcend material experience and historical time. The devout are asked to kiss these pictures as if greeting members of their family. In more modern examples, the relationship between spiritual and earthly realms implies a critique of materialistic striving. Both Van Gogh's *Starry Night*, with its explosion of spiraling nebulae coursing above a landscape of feeble church steeples, and Munch's *The Scream*, with its flamelike figure reduced to the very sound lines of its harrowing utterance, lament the suffocation of daily existence: its little churches, bridges, and top-hatted bourgeoisie. Van Gogh and Munch penetrate surfaces to escape "into a world where there is nothing but the spirits of things."

Many petroglyphs idealize ecstasy in the same way. But we receive these ancient marks with a benign confusion. We call them primitive, childlike, charming. We patronize them with words like modernistic. We reduce their intensity by neutralizing the fear that otherness still has the power to induce. This fear can lead to acts of mutilation and dismemberment that have the aura of fable: a petroglyph site in northern New Mexico was recently ground up into small stones to make riprap retaining walls, destroying forever the holy coherence. Yet fragments of the original drawings are visible. Even as ballast they exert power like glowing embers of a once-great fire.

When Salvatore Mancini entered the Southwest to document the petroglyphs, his aim was strictly personal. As a photographer born in Southern Italy where certain trees, stones, and religious

shrines are revered by rural townspeople and peasants, he began to investigate the drawings and paintings on stone as a spiritual side of America, virtually ignored by the general population and eclipsed in our current ignorance of the life of the soul. In the fierce figures, and the decisiveness of the marks themselves, he found the guides he needed as an artist.

It was comforting for him to walk the long distances from his car, with camera and tripod, to places knowing scholars keep from those who might not understand. He began by describing the rock art in clear daylight, stepping back to grasp the entire site, then moving in closer to feel the individuality of paint and carving. In the course of extracting the pictures from their sites through the geometry imposed by photographic framing, he found vantage points to help recall the surprise of first discovering the pictures' hiding places. Although he found his compositions beautiful, he realized he had not conveyed the holy intentions of their makers.

Working into evening he noticed the marks changing in the shifting light. Certain times of day revealed or obscured entire linear patterns, giving the figures a wavering pulsation they had not possessed hours earlier. Waiting until nightfall to begin photographing, he noticed that in lamplight, in the glow of a match, or in the long exposures during which he traced the figures with his flashlight, the images jumped off the wall and began to vibrate like electronically transmitted brain waves. While these night-sky pictures challenged the objective standard that anthropologists value in

archival description, the photographer found in them a pictorial equivalent of the shamanistic experiences that inspired so many petroglyphs.

Dwelling in the grave obscurity of worlds modeled in extraterrestrial light is also not unlike the phenomenon of photography itself, whose negative, with its white-line shadowings, the first camera artists revered as the darkling alchemical side of mechanical reproduction. In such evocations the greening earth seems strange, yet dark pictures have the power to conjure ancient ways of knowing. "Seeds sprout in the darkness of the ground before they know the summer and the day. In the night of the womb the spirit quickens into flesh." There are no linear geometries here. In the darkness we see beyond our senses. A sacred wholeness is restored through the continual contrast of daylight and night, earth and spirit. Black Elk remembered that "This was the wish of the Grandfathers of the World."

Eugenia Parry Janis

All quotes from *Black Elk Speaks, Being the Life Story of a Holy Man of the Oglala Sioux*,
as told through John G. Neihardt (Flaming Rainbow)
(1932; reprint, New York: Washington Square Press, 1972).

INTRODUCTION:
SHAMANIC ECHOES

mages painted and engraved on stone in the landscapes of the Greater Southwest capture the rich cosmologies and worldviews of the prehistoric past. Rock art is a graphic document of ideas about sacred geography and the complex interaction between people, places, and supernaturals. It is a statement from worldviews in which humans, nature, and landscape are seen as related in a single, interlaced fabric.

Although most of the North American cultures that made rock art have passed into oblivion, and the descendants of the artists have lost entirely or maintain only a tenuous linkage to this ancestral legacy, rock art sites in some parts of the Southwest continue to carry meaning to their cultural

heirs. Images painted and pecked on stone contain the information of religious traditions. The locations of rock art confirm the importance of place, the presence of ancestors. As well, the figures themselves—these graphic art forms painted, pecked, incised or abraded on boulders, cliffs, and rocky outcrops, in rock shelters and on canyon walls—continue to evoke responses and questions from archaeologists and contemporary explorers of imagery from the prehistoric past.

Rock art consists of both paintings and petroglyphs. Paint was applied with brushes made from available fibers, plant husks, smeared on with the fingers, and sometimes even sprayed on by mouth. Petroglyphs, or rock carvings, were most commonly made by pecking with stone tools, although some figures are incised with a sharp instrument.

Among the elements drawn on stone, the human figure in its many shapes and various adornments is perhaps the one that holds the strongest attraction. Its presence reminds us of ourselves, of our kinship with the past, establishing a link with our predecessors. Although familiar, the various modes of stylization of the human form employed by the ancient artists, and the activities in which these figures are engaged, suggest that one is viewing beings, at once human yet also supernatural, estranged from the daily world. The humpbacked flute player as a symbol of fertility, the arrow swallowers, the bear shaman, and the shield bearers all illustrate esoteric elements of Pueblo ceremonialism and ritual. The Mimbres man from southern New Mexico is pecked in simple outline, poised as an animal. A second profile, elaborated and echoed

in the edge of the rock immediately in front of him, inextricably links this figure with the stone itself. The detached hands and arms from Three Rivers and the face without an outline are powerful understatements that demand observer participation. Like the body silhouettes excavated or drawn into the earth by the late artist Ana Mendieta, these rock art figures, by their very simplicity and ambiguity, suggest more than they portray.

Shamanic voyages to supernatural realms by those trained in the techniques of ecstatic trance lie behind many of the compelling and often startling human figures encountered in rock art such as the Barrier Canyon–style paintings of eastern Utah and the Pecos River–style paintings of the lower Rio Grande in West Texas. These paintings were made by members of ancient hunter-gatherer societies and focus on the portrayal of elongated, highly abstract human images. There is good ethnographic evidence in western North America to show that rock art was often made by shaman artists to communicate to neophytes, or initiates, the mysteries of the supernatural. Neophytes also may have recorded their own experiences. Much of this rock art seems to portray participants on otherworldly journeys or on transcendental planes in states of trance or ecstasy for the purpose of acquiring supernatural power. The figures of the Barrier Canyon and Pecos River styles are not ordinary, and their visual departure from the natural serves to create for the observer an illusory world detached from the here and now. Disproportionate bodies, arms and legs, and projections from the head may be sensations actually experienced in a trance state. Enormous eyes on these figures suggest the shaman's supernatural power of seeing—a spacial capacity that

plays a significant role in healing, hunting, and in other areas in which shamans marshal their talents. Shamans were often assisted into their trance by physical stress such as fasting and sleep deprivation as well as through the use of hallucinogens. Other figures also inspired by shamanic experiences include the complex bird-men, created by unique combinations of lines and circles, that characterize the Interior Line–style petroglyphs near Dinwoody, Wyoming.

Images carved and painted on stone reveal a close relationship between humans and the rest of nature. In the cosmologies of the artists, humanity was thought of as an integral part of life's web on every level of existence. In such a universe, natural forces are propitiated, cajoled, appealed to for the benefit of humankind, who was thought to hold a somewhat powerless position in the scheme of things. Humanity therefore sought to acquire access to the powers of various animals. Wandering lines establish visual linkages between human and animal forms that suggest kinship or power relationships. Acquiring power from other life forms may also be illustrated in rock art that shows transformational themes such as human figures with plant or animal attributes. The Dinwoody petroglyphs that link owl and human characteristics or the image found in Utah of a shaman with roots growing from his feet are cases in point. In the Fremont petroglyphs of Utah and occasionally in the painting of the Pecos River style of West Texas, shamans and other ceremonial participants are shown wearing headdresses of horns or antlers, symbols of supernatural power. Shaman figures in Barrier Canyon and Pecos River style are frequently surrounded by animal spirit helpers or

guides on the shamanic journey. These helpers are often birds. Birds throughout the world of shamanism are the ultimate symbol of the flight of the soul to celestial realms, a magic flight made possible through trance. In addition to picturing birds alongside shamanic figures, the shaman himself may be shown as a winged being.

In most rock art, animals were selected for portrayal because of their metaphorical values and ritual powers. An esoteric ideology surrounds these figures, indicated by their frequent nonnaturalistic attributes. Some figures, like animals in a panel from central Utah, lack natural counterparts or are shown with characteristics of more than one species. As discussed above, animals may also be associated with human figures in unusual ways. Such relationships are exemplified by the bird-headed Basketmaker shamans or the snake, presumably a spirit helper, above the shaman's head.

Textile and ceramic designs and other seemingly nonrepresentational patterns pecked and painted on rocks by southwestern horticulturalists, such as members of the Trincheras culture of Sonora, are more difficult to assess, both in regard to their meaning and the reasons for making them. Why was it important to these artists to create designs, seemingly originating on or otherwise confined to domestic artifacts, in wild or sacred places? Were they made for purely aesthetic impact or for other reasons? The presence in the landscape of these pottery and textile motifs, with subjects obviously related to ritual and ceremony, suggests that the former had connotations that exceeded the decorative realm. In most instances, however, their cryptic meanings continue to elude us. What deeper significance did these

elements have for their makers? What did they communicate to others, if anything? Mancini's photographs encourage us to question these things. Some scholars might suggest that these designs relate to entoptic phenomena, neuropsychological patterns seen during trance states. This is one possible explanation, but one that is by no means provable.

The interaction between the photographer and the rock art he or she photographs is a creative process. The modern trespasser into the surrounding wilderness solitude and quiet of rock art sites continues to be moved by these powerful figures. Each person responds in his or her own way. It is the visual artist's prerogative to interpret and reinterpret. The very selection of images in this volume represents a regrouping of imagery in which Mancini brings together rock art from different regions and cultures to make his own dynamic statement. These photographs exceed a routine documentation of rock art and seek more than mere aesthetic appreciation. Through black-and-white photography, Mancini emphasizes the abstract quality of the art. He pushes his medium and pulls his observers into his responses to these prehistoric visual declarations of cosmology. He has created a mysterious aura around the textile and pottery designs simply by placing them in a context of shamanic and other ritual themes. By manipulating the contrast in his photographs, these designs emerge in a startling manner from their landscape contexts. The shamanic figures in his photographs seem to fly across the rocks or vibrate with energy. By creating unexpected spatial relationships through selectively emphasizing sunlight and shadow, and by highlighting

selected elements in nighttime shots, he communicates afresh the power latent in rock art.

Rock art is enduring yet fragile in its landscape setting. Ironically, humankind poses the greatest threat to the preservation of this irreplaceable legacy through ignorance, wanton vandalism, or destruction in the name of development. Efforts to preserve and protect rock art sites are necessary to ensure their existence for future generations.

Polly Schaafsma

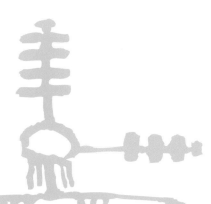

On the Edge of Magic:
Photographs, Legends, and Chants

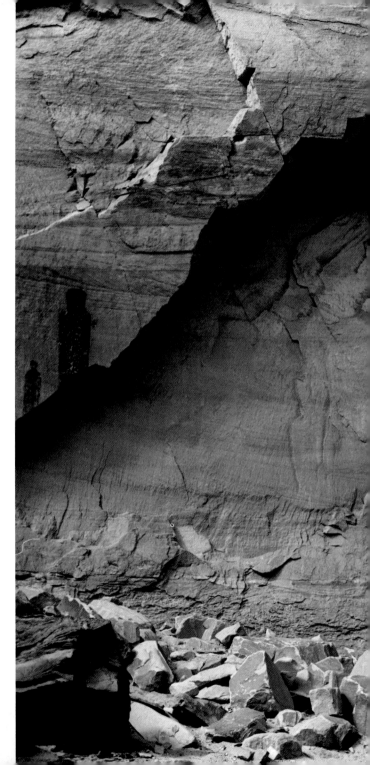

Now that you have come out standing
 to your sacred place,
That from which we draw the water of life,
Prayer meal,
Here I give to you.
Your long life,
Your old age,
Your waters,
Your seeds,
Your riches,
Your power,
Your strong spirit,
All these to me may you grant.

 –Zuñi prayer

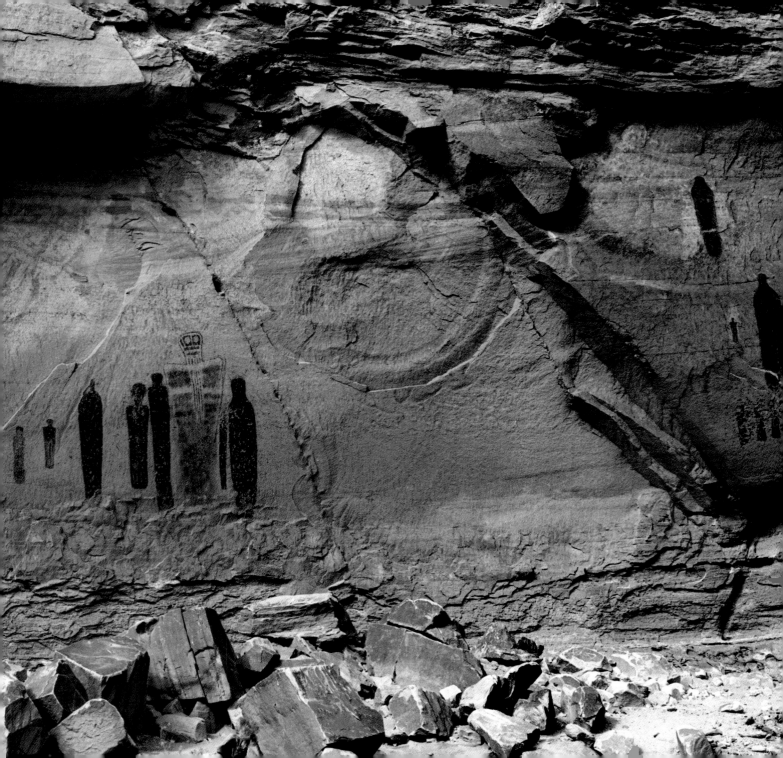

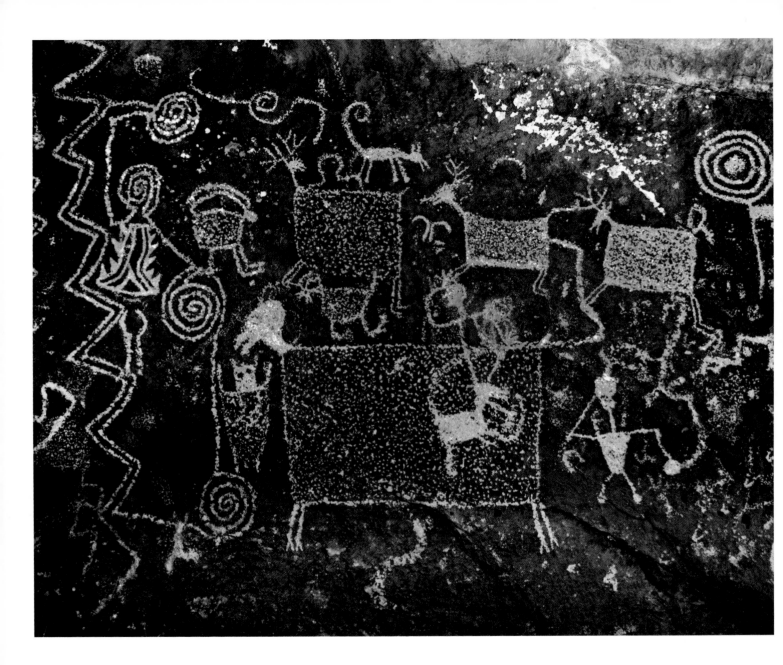

So they called the people of the
southern space the Children of
Summer, and those who loved the
sun most became the Sun people.
Others who loved the water became
the Toad people, or Turtle people, or
Frog people. Others loved the seeds
of the earth and became the Seed
people, or the people of the First-
growing grass, or of the Tobacco.
Those who loved warmth were the
Fire or Badger people. According to
their natures they chose their totems.

—Excerpt from Zuñi creation myth

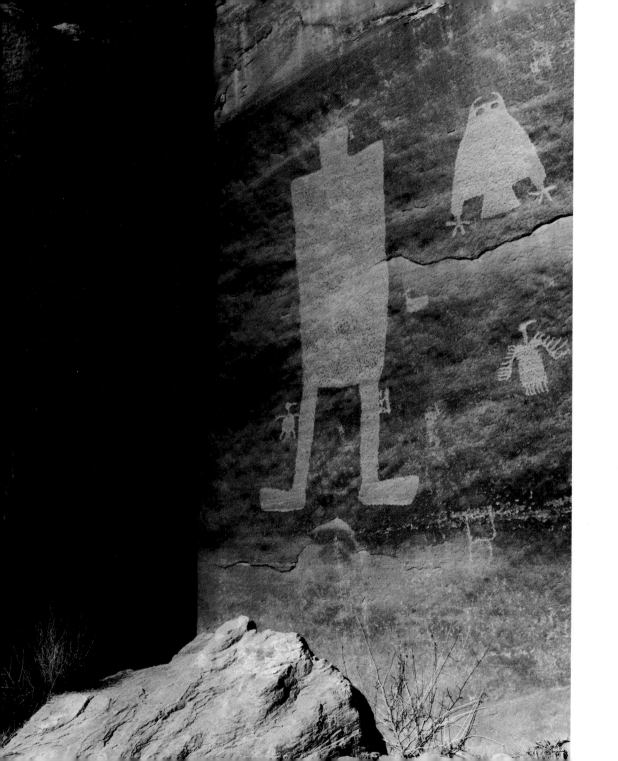

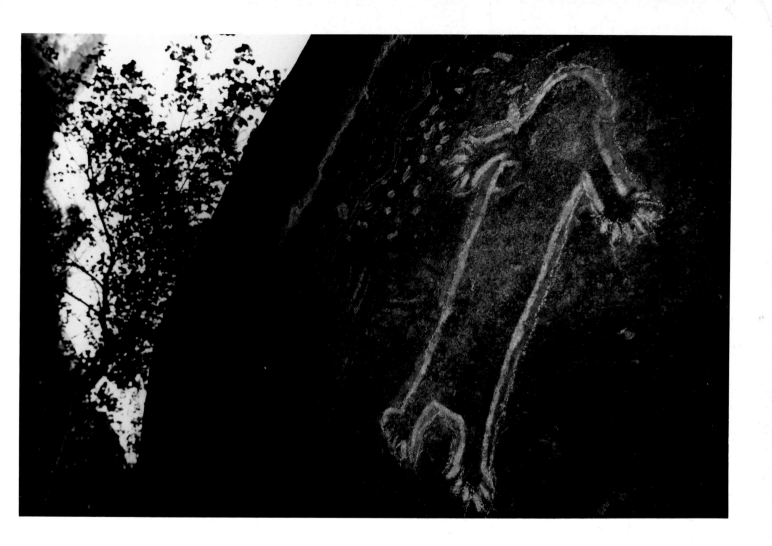

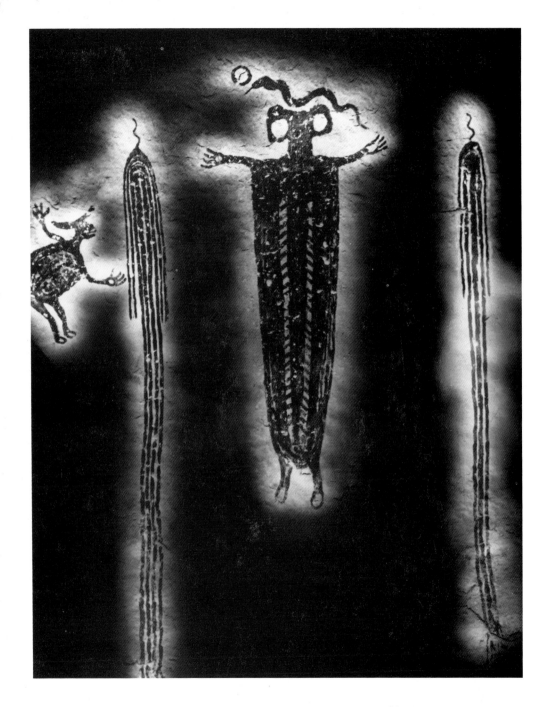

Great-man created the world and all
the people. At first the earth was
very hot, so hot it was melted, and
that is why even today there is fire in
the trunk and branches of trees, and
in the stones.

Lightning is Great-Man
himself coming down swiftly from
his world above, and tearing apart
the trees with his flaming arm.

Thunder and Lightning are
two great spirits who try to destroy
mankind. But rainbow is a good
spirit who speaks gently to them,
and persuades them to let the
Indians live a little longer.

—Maidu creation myth

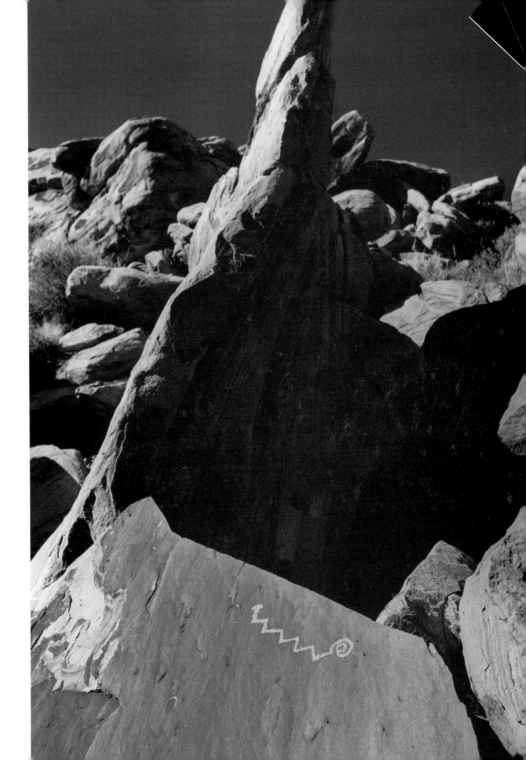

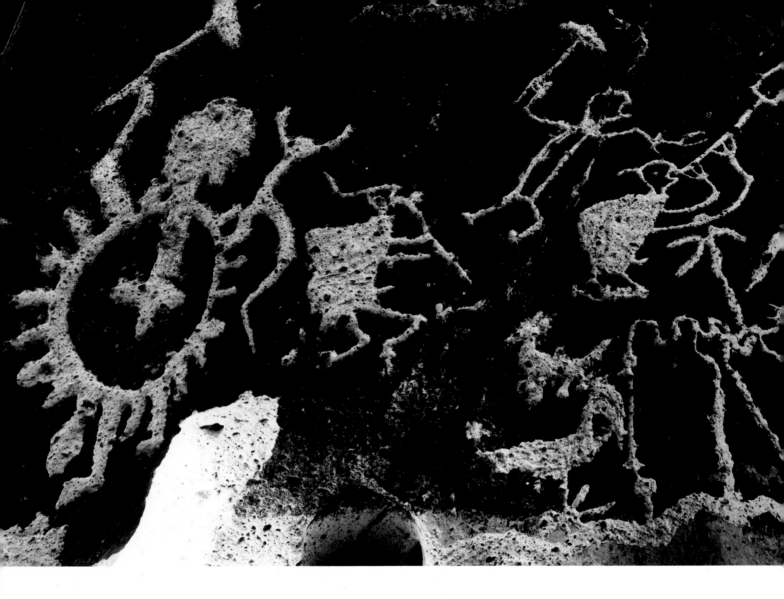

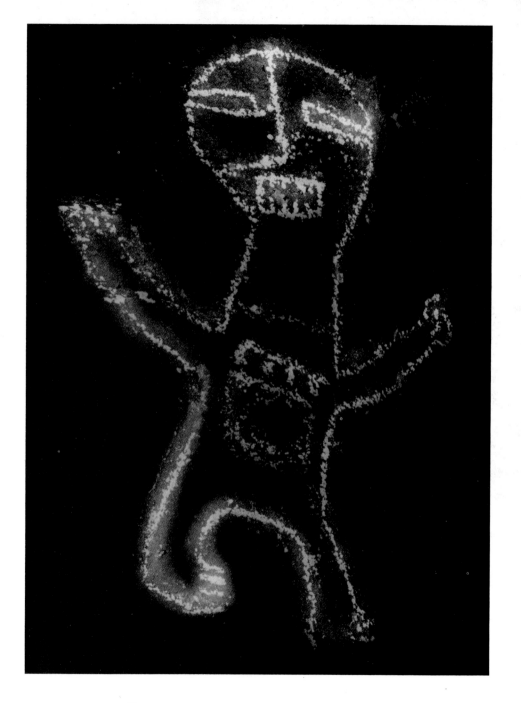

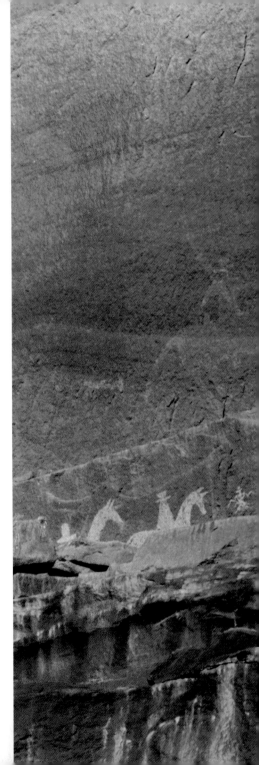

Rubbed with the summits of the mountains,
Now among the alien gods with weapons of magic am I.
Now upon the beautiful trail of old age,
Now among the alien gods with weapons of magic am I.

Now, Offspring of the Water, among men am I.
Now among the alien gods with weapons of magic am I.
Rubbed with the water of the summits,
Now among the alien gods with weapons of magic am I.
Now upon the beautiful trail of old age,
Now among the alien gods with weapons of magic am I.

—Excerpt from Navajo war song

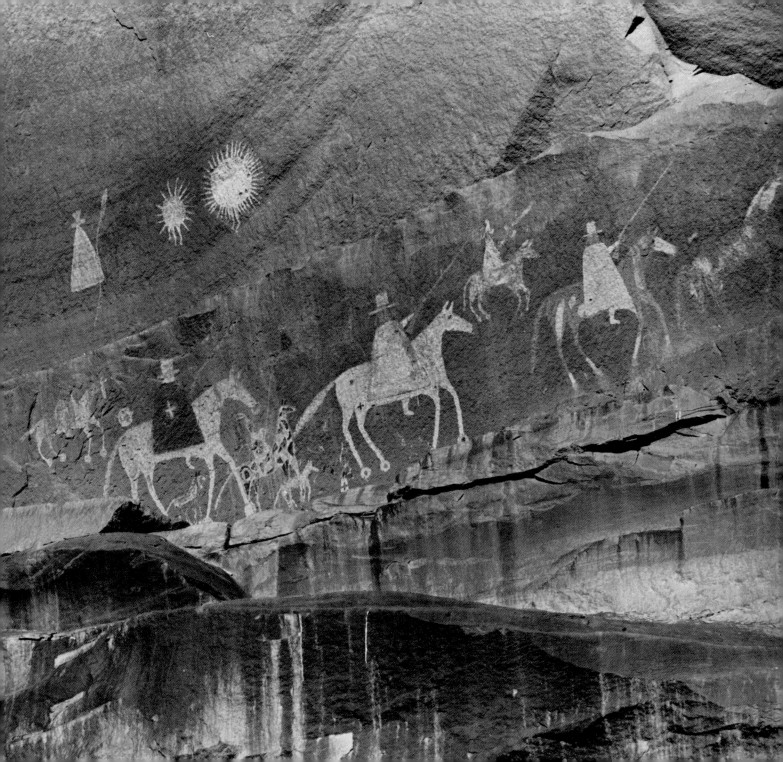

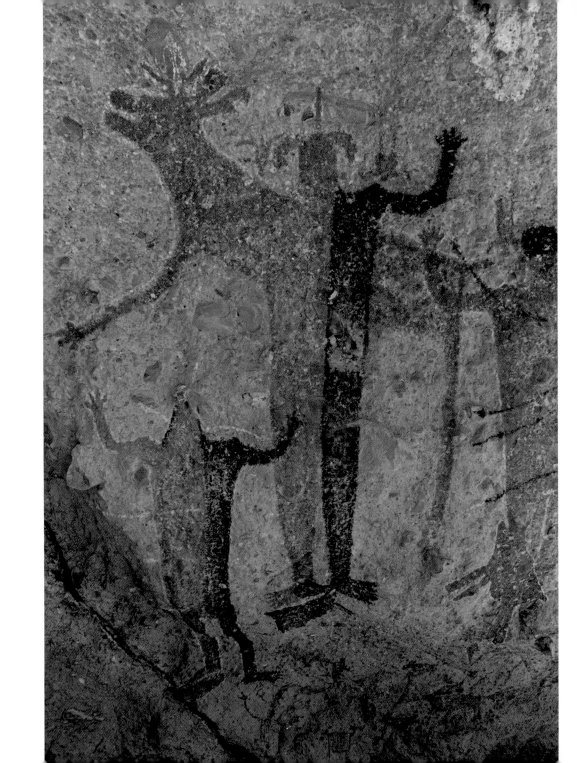

At the south
Where the white shell ridges of the earth lie,
Where all kinds of fruit are ripe,
We two shall meet.

From there where the coral ridges of the earth lie,
We two will meet.
Where the ripe fruits are fragrant,
We two will meet.

—Apache deer song

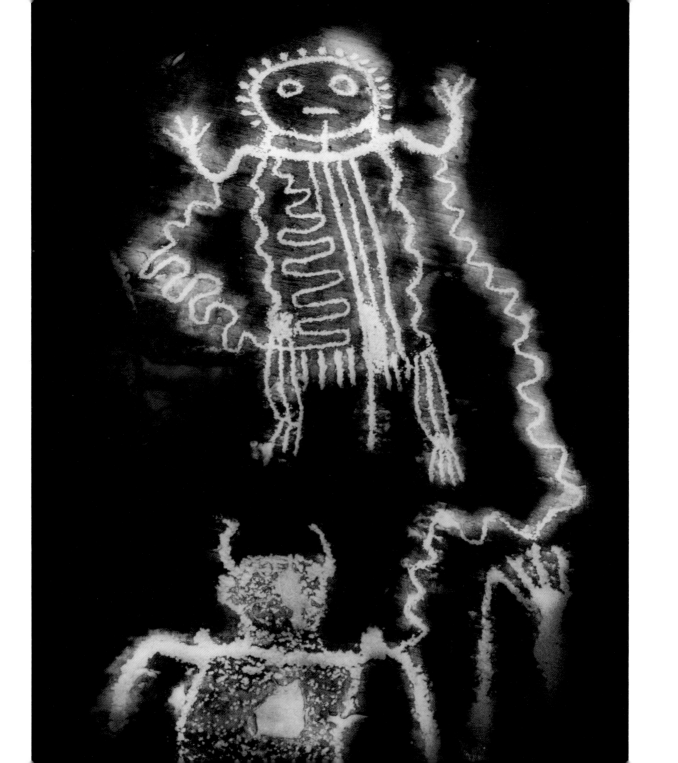

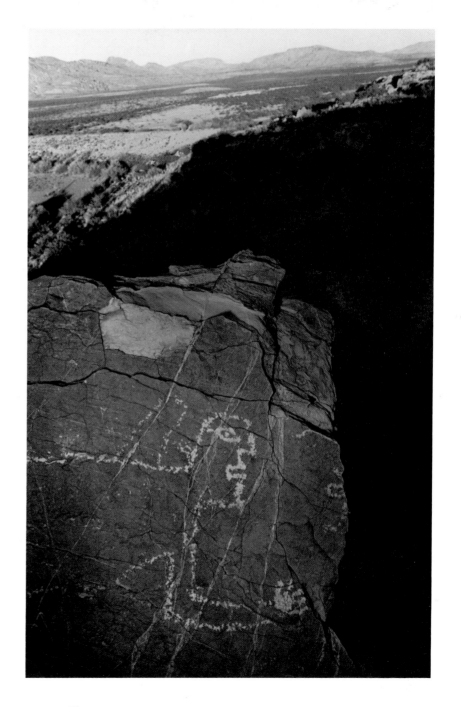

It increases and spreads
In the middle of the wide field
The white corn, it increases and spreads
Good and everlasting one, it increases
and spreads.

—Navajo growth song

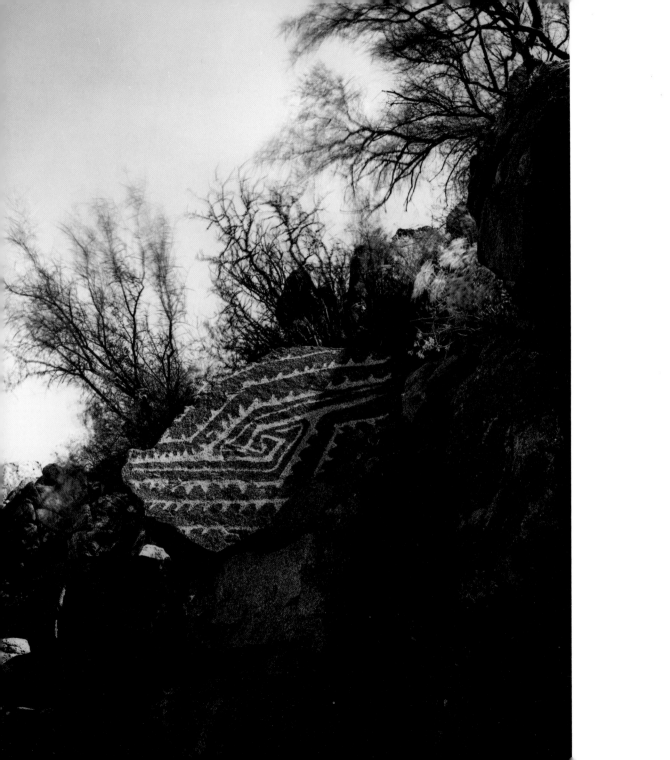

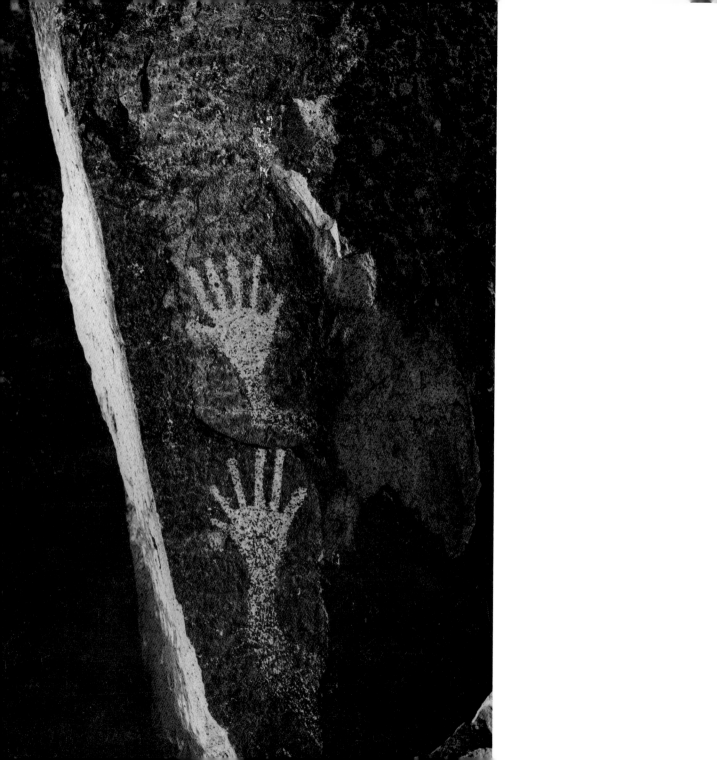

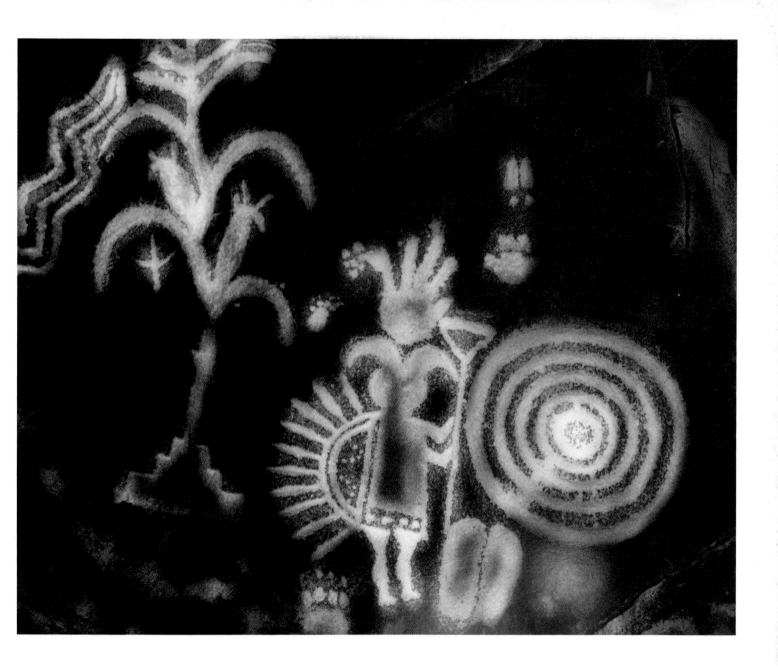

The Creation of the Earth

Earth Magician shapes this world.
 Behold what he can do!
Round and smooth he molds it.
 Behold what he can do!
Earth Magician makes the mountains.
 Heed what he has to say!
He is that which makes the mesas.
 Heed what he has to say!
Earth Magician shapes this world;
 Earth Magician makes its mountains...

—Pima creation song

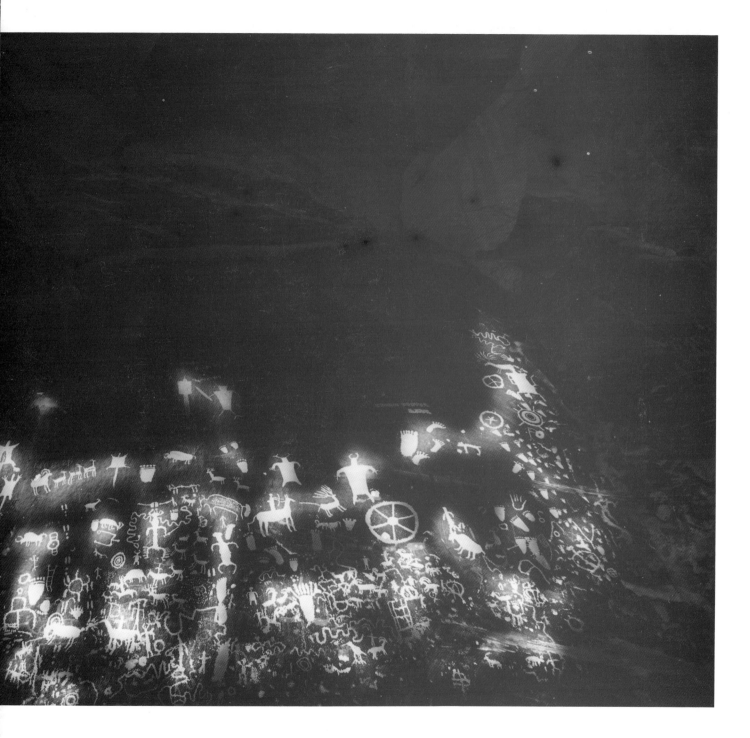

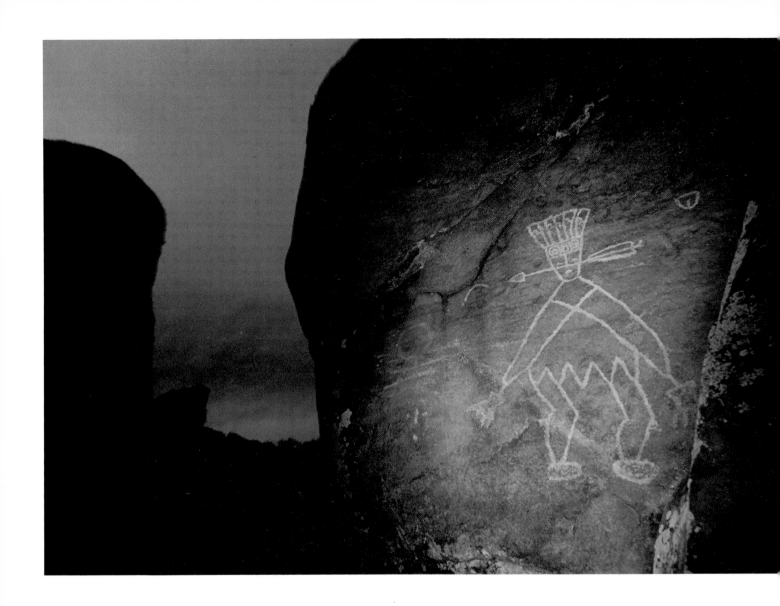

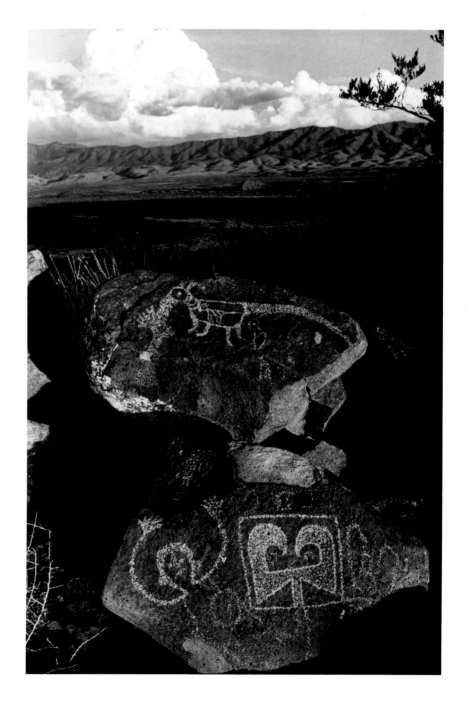

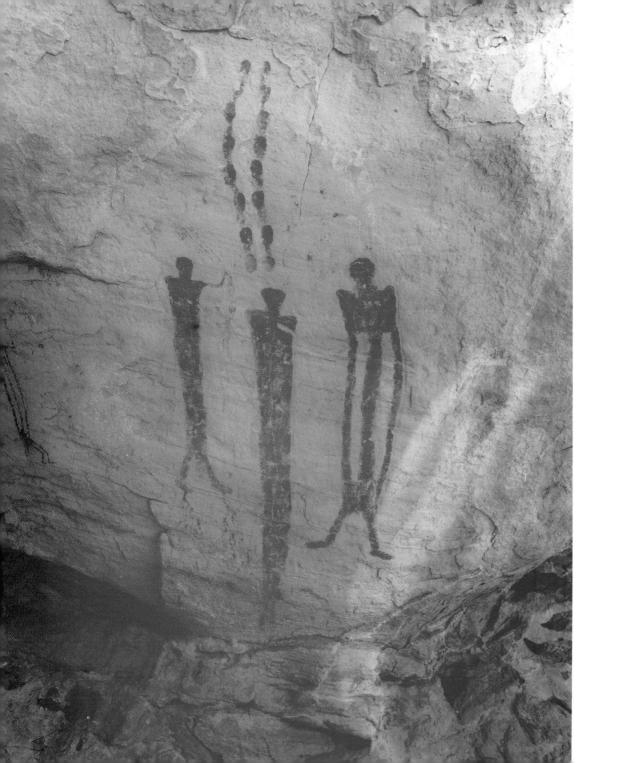

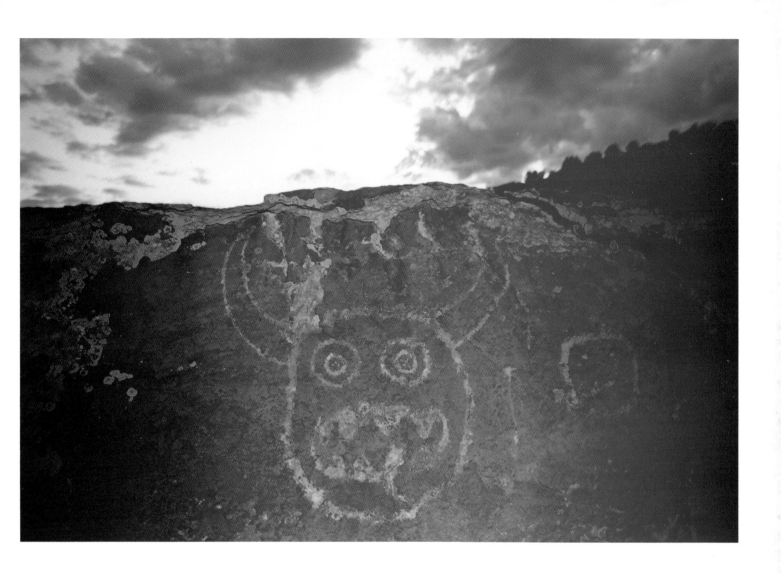

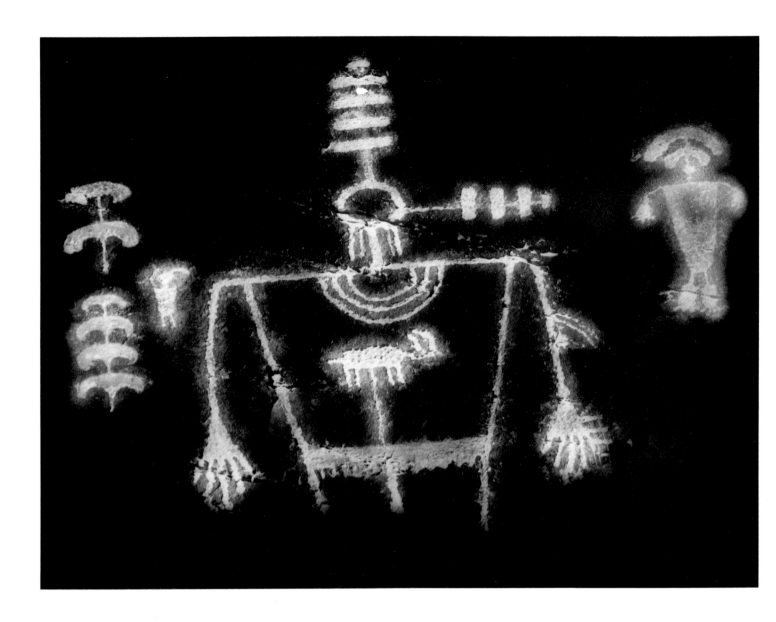

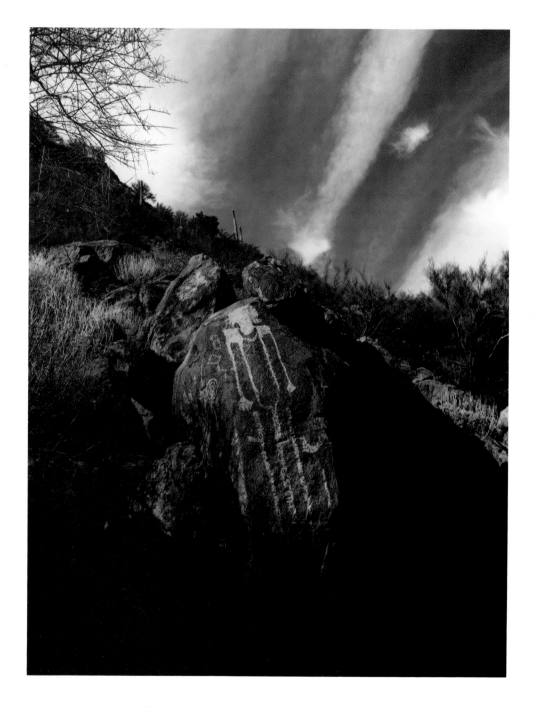

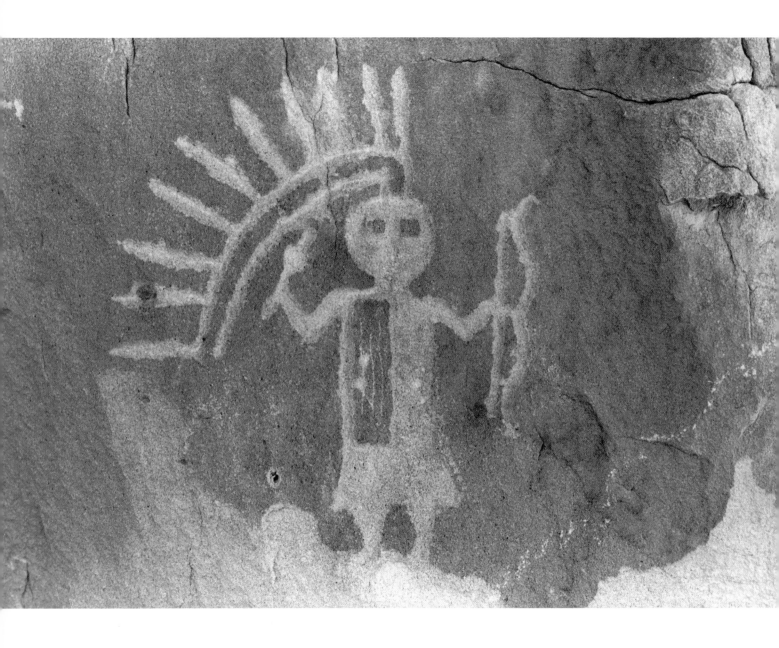

A hat of eagle feathers;
 A hat of eagle feathers,
A headdress was made for me
 That made my heart grow stronger.

—Excerpt from Pima coyote song

I am the Turquoise Woman's son.
On top of Belted Mountain
Beautiful horses–slim like a weasel.
My horse has a hoof like striped agate;
His fetlock is like fine eagle-plume;
His legs are like quick lightning.
My horse's body is like an eagle-plumed arrow;
My horse has a tail like a trailing black cloud.
I put flexible goods on my horse's back;
The little Holy Wind blows through his hair.

 Before me peaceful,
 Behind me peaceful,
 Under me peaceful,
 Over me peaceful,
 All around me peaceful–
 Peaceful voice when he neighs.
 I am Everlasting and Peaceful.
 I stand for my horse.

—Excerpt from Navajo horse song

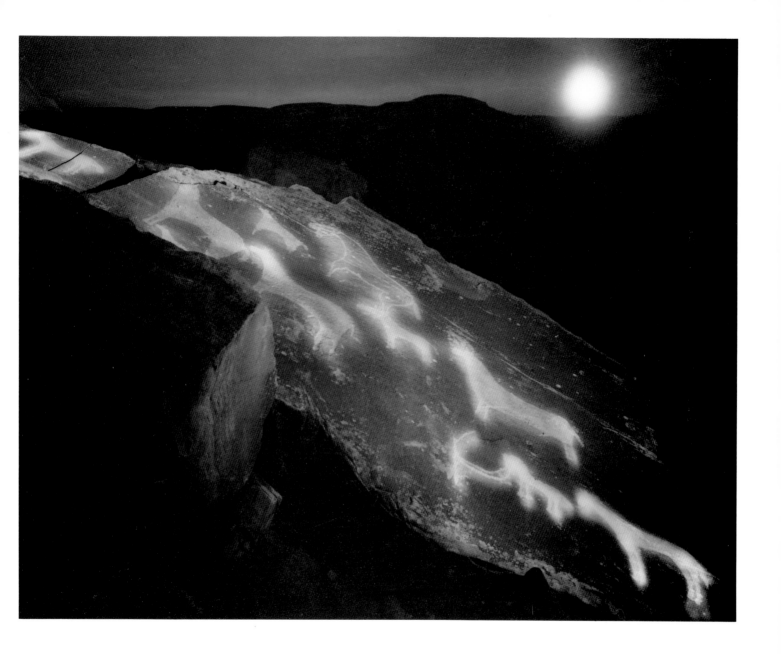

I am No-ho'nay Yon'nee
Toward the east the black tail of the roadrunner stands up.
I walk up to it.
I came up to it.
I walked on top of the feathers.
I am walking on top of it.
I am riding on the lightning.
The lightning is given to me.
I control the lightning now.
I am holy with it now.

—Navajo feather dance song

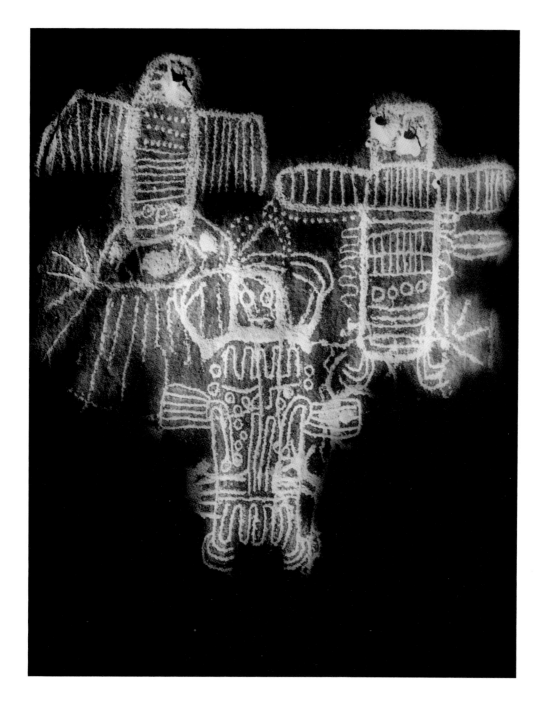

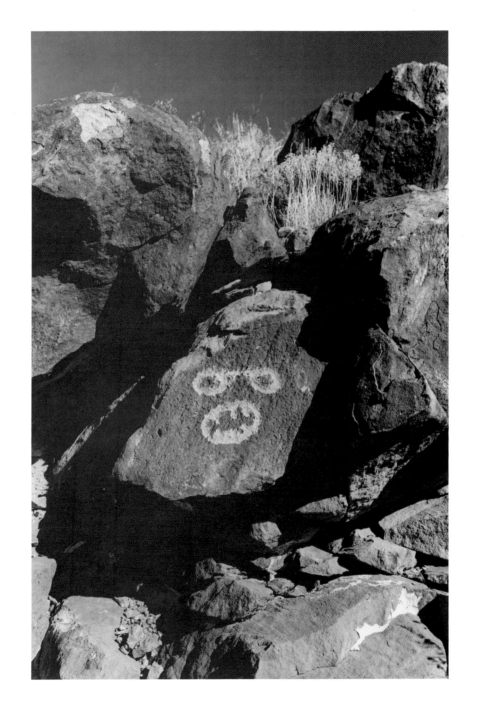

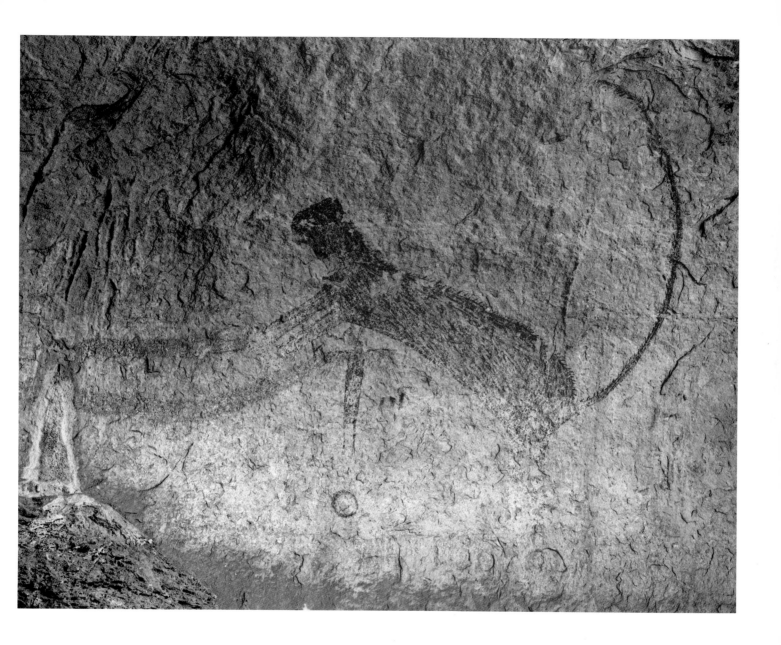

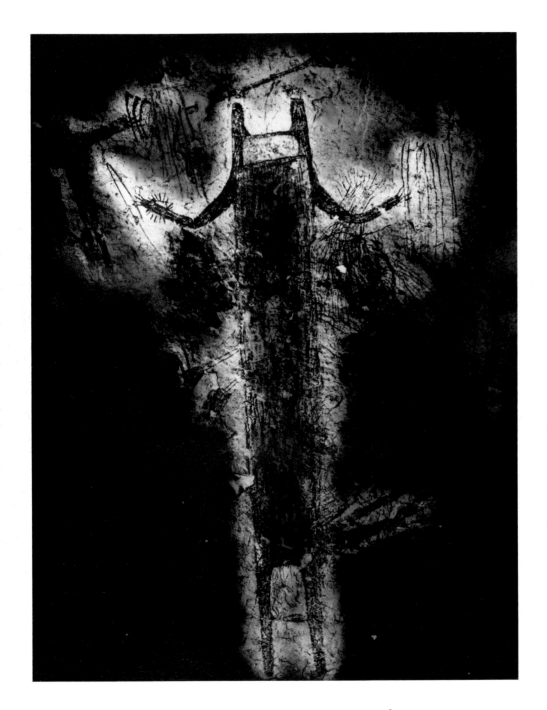

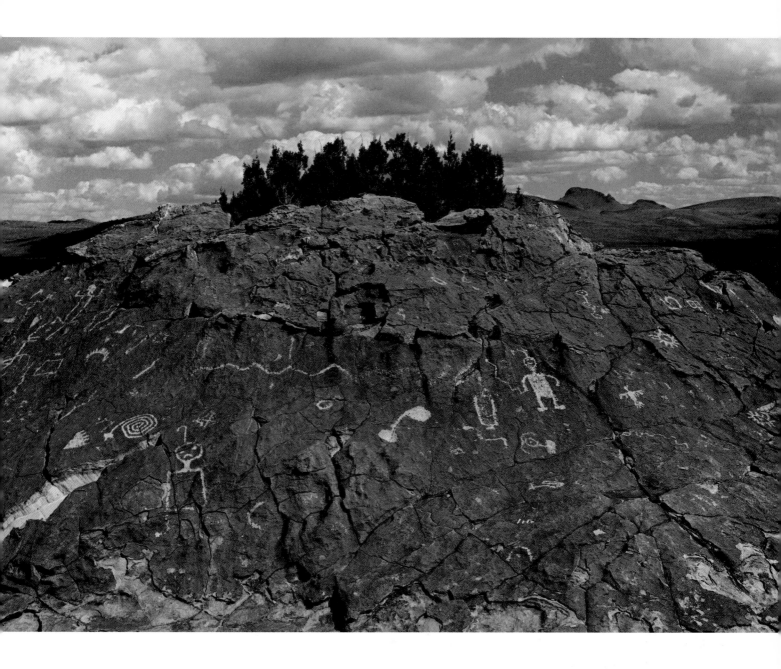

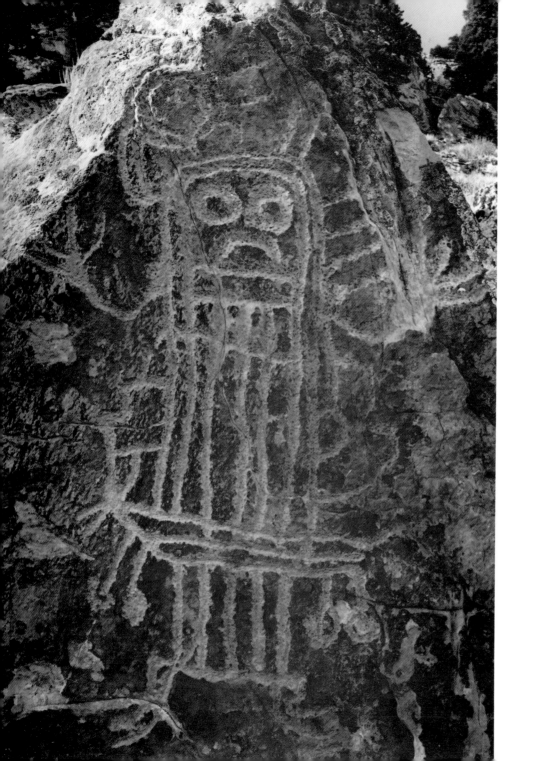

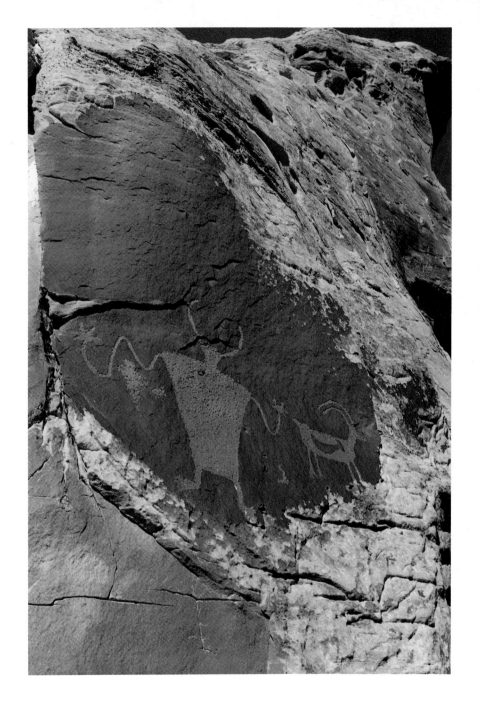

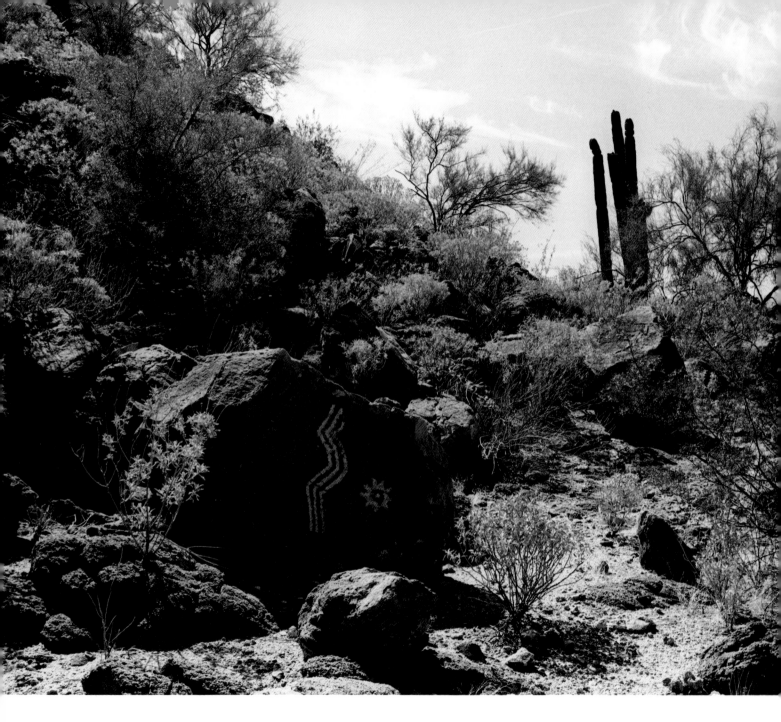

Who is this man running with me,
The shadow of whose hands I see?

—Excerpt from a Pima foot race song

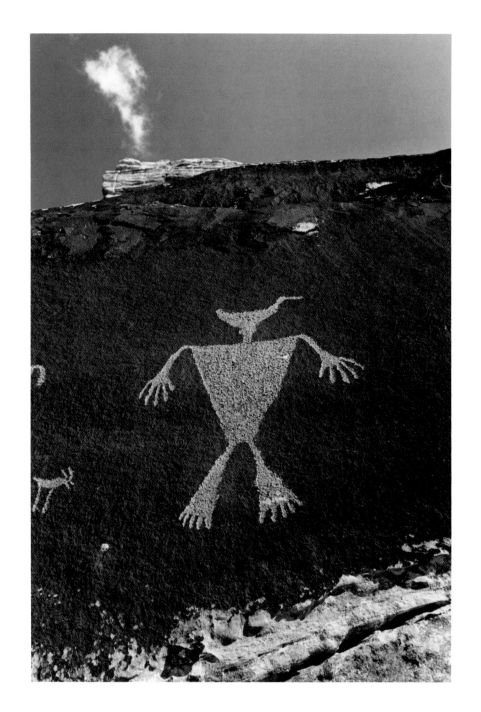

White Floating Clouds.
Your thoughts
Come to us,
All your people,
Your thoughts,
Come to us.
Who is it?
Clouds like the Plains.
Your thoughts
Come to us.
Who is it?
Arrow of Lightning.
Your thoughts
Come to us.
Who is it?
Earth Horizon.
All your people,
Your thoughts,
Come to us.

—Pima rain song

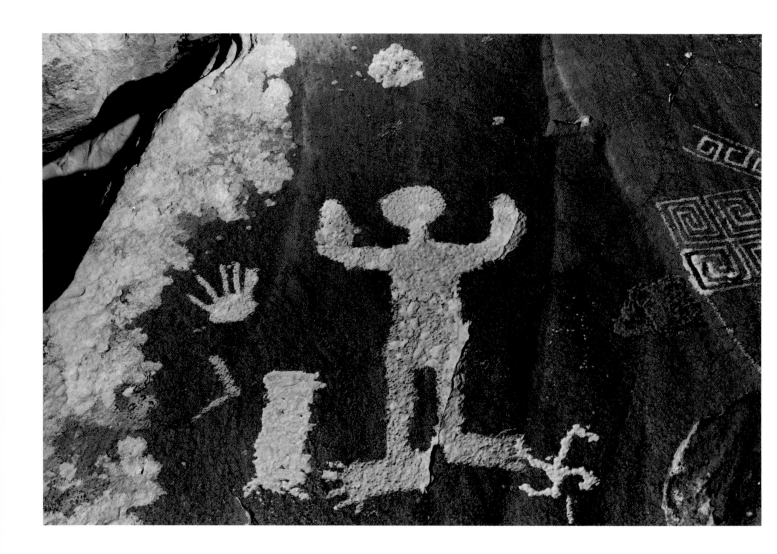

Swift and far I journey,
Swift upon the rainbow.
Swift and far I journey,
Lo, yonder, the Holy Place!
> Yea, swift and far I journey.
To Sisnajinni, and beyond it,
> Yea, swift and far I journey;
The Chief of Mountains, and beyond it,
> Yea, swift and far I journey;
To Life unending, and beyond it,
> Yea, swift and far I journey;
To Joy Unchanging, and beyond it,
> yea, swift and far I journey.

—Navajo mountain song

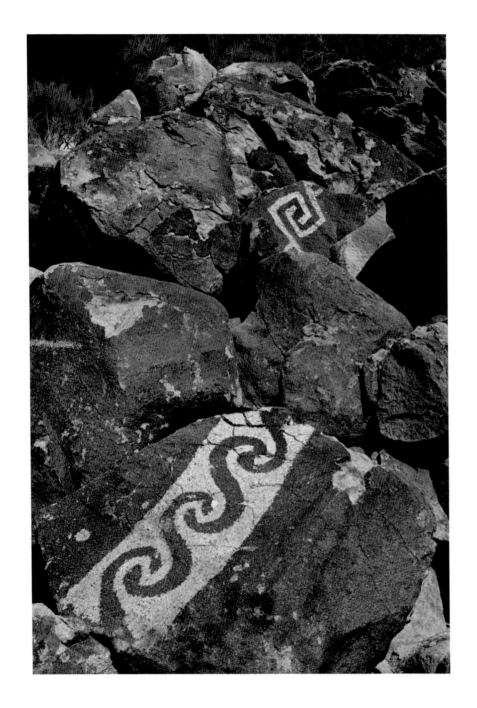

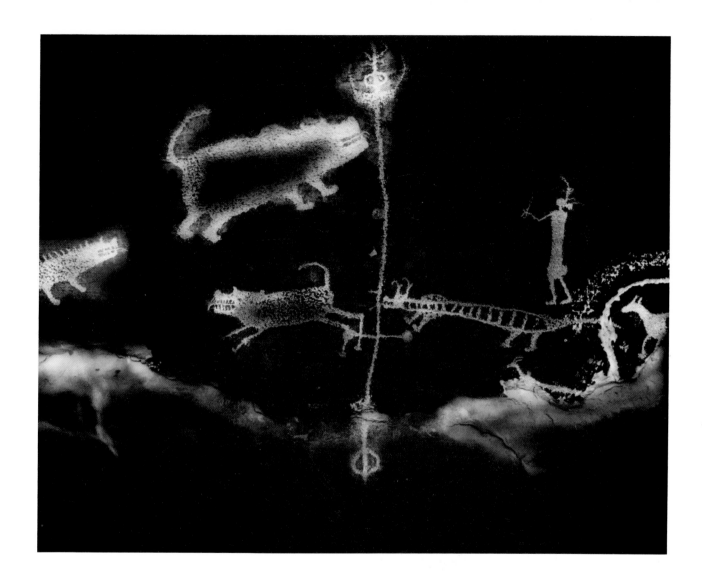

He stirs, he stirs, he stirs;
Among the land of dawning he stirs, he stirs;
The pollen of dawning, he stirs, he stirs;
Now in old age wandering, he stirs, he stirs;
Now on the trail of beauty, he stirs, he stirs;
He stirs, he stirs, he stirs.

—Navajo waking song

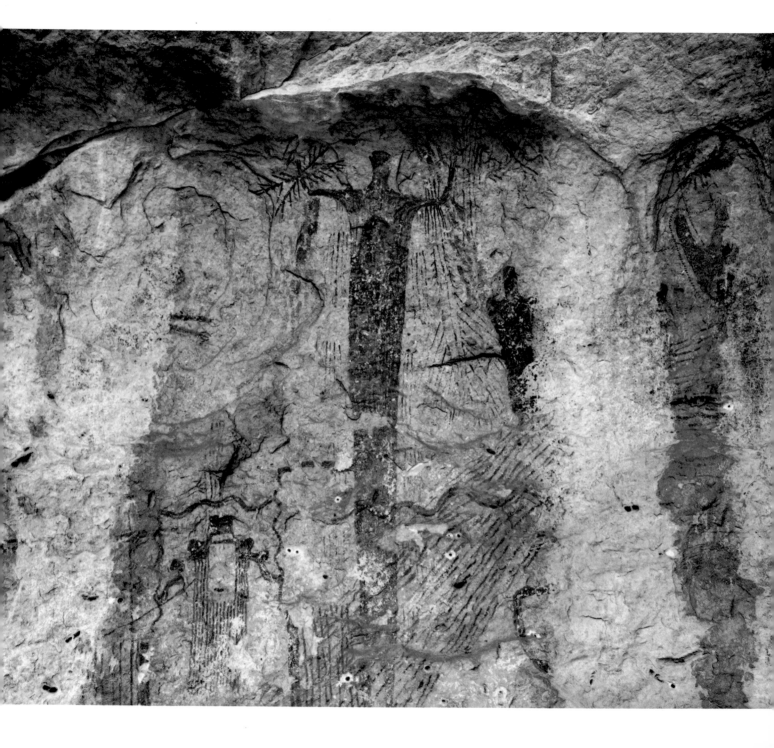

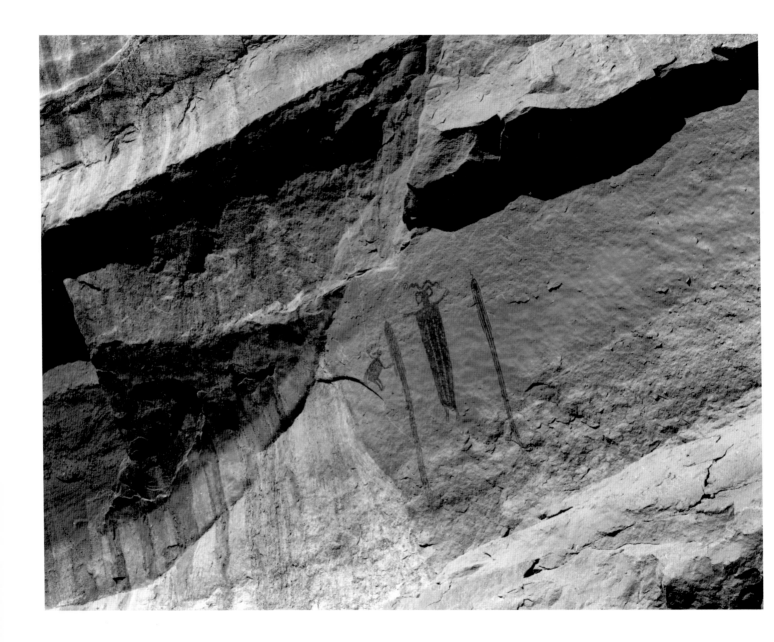

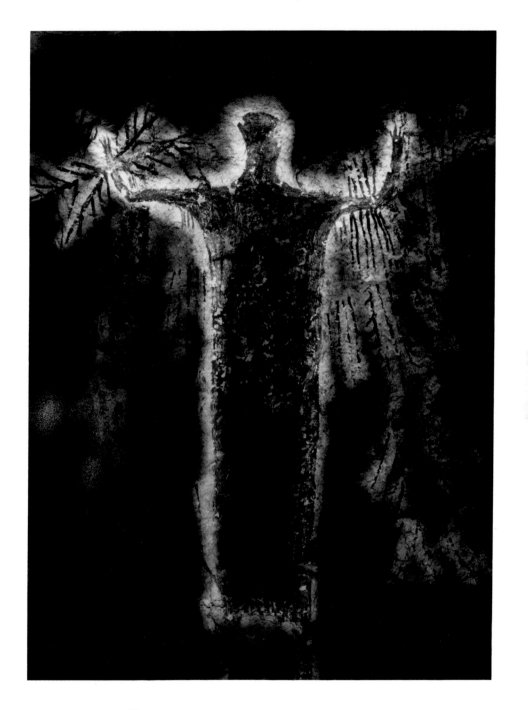

I will be happy forever, nothing will hinder me;
I walk with beauty before me,
I walk with beauty behind me,
I walk with beauty below me,
I walk with beauty above me,
I walk with beauty around me,
my words will be beautiful.

—Navajo prayer

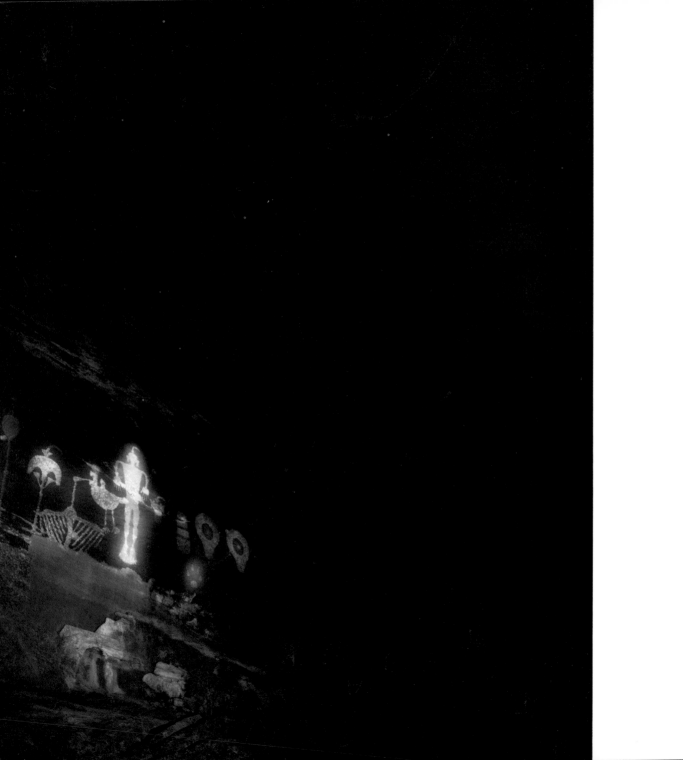

Glossary

The following is a very basic description of the groups who created the rock art pictured in this book. In addition to the peoples and cultures listed below, prehistoric and historic Ute and Shoshoni Indians practiced rock art in their native regions.

Anasazi

An archaeological term for the farming ancestors of the Pueblo Indians who raised corn, beans, squash, and sometimes cotton and who lived in the Four Corners region of the Colorado Plateau before 1300.

Basketmaker

The earliest of the Anasazi (ca. 800 B.C. to A.D. 700) known for their superb basketry.

Comondu

The late archaeological component of hunter-gatherers of central Baja California (ca. 300-1500).

Fremont

An archaeological classification that includes the various farming populations in Utah between ca. 600 and 1300. The term embraces several regional manifestations.

Hunter-gatherers

Mobile populations whose lives were was based on hunting and foraging for wild foods as they became seasonally available. Social groups were small and consisted of kin-related bands. In certain regions, such as the Great Basin, a hunter-gatherer lifestyle persisted for thousands of years until historic times.

Mimbres

A prehistoric farming culture of the Mogollon region of southern New Mexico and southeastern Arizona between ca. 1000-1150. The Mimbres culture was distinguished by its pueblo-style masonry villages and its black-on-white ceramics with detailed abstract patterning and unusual life forms.

Mogollon

A broad term incorporating several regional configurations and temporal phases of prehistoric farmers in southern New Mexico, southeastern Arizona, and northern Mexico between ca. 200 B.C. to A.D. 1400. The Jornada Mogollon occupied the desert regions of southern New Mexico, West Texas, and northern Chihuahua.

Navajo

A branch of Athabaskan-speaking immigrants into the American Southwest after ca. 1450/1500, distinguished in early historic times by their adoption of Puebloan farming practices and sheep raising. Today their reservation includes parts of southern Utah, northwestern New Mexico, and northern Arizona. They are well known for their silver and turquoise jewelry, rugs, and ritual sandpaintings.

Pueblos

Residents of Anasazi towns and the later Pueblo Indians of contemporary times. The word is Spanish in origin and refers to the masonry and/or adobe, multistoried, flat-roofed buildings of the native Pueblo villages.

Trincheras

A prehistoric farming province in southern Arizona and adjacent parts of Sonora, Mexico, between 700 and 1450, distinguished archaeologically by the building of "trincheras," or terraced hillsides.

Ute

Several groups of southern Numic speakers (a branch of Uto-Aztecan) whose traditional territory was most of central and eastern Utah and western Colorado. The Utes are heirs to a long hunter-gatherer tradition.

Western Archaic

A general archaeological term used to refer to prehistoric hunter-gatherer cultures in the American West.

Yokuts

A seminomadic tribe of Penutian speakers of the San Joaquin Valley and foothills of the Sierra Nevada in south-central California known for its shamanic rock art tradition.

Captions

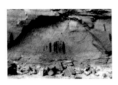

Page 28-29 Shamanic figures of Barrier Canyon are arranged as a group centered within a natural arching recess in a sandstone overhang. The central figure is between six and seven feet tall. The paint, applied by spraying, contributes to the composition's ethereal appearance. Circa 4000–50 B.C. Canyonlands area, east-central Utah.

Page 30 Petroglyphs of mountain sheep, deer, or possibly coyotes dominate this group of drawings that may be of Jornada Mogollon origin. Spirals, large double zigzags, and other geometric designs contrast with the life forms. A triangular-bodied human figure with hand-held objects appears in the lower right. Circa 1050–1400. Rio Grande region, Texas.

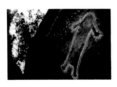

Page 32 Solidly pecked, tall, armless human form with owl and smaller birds and animals, Fremont culture. 600-1300. Moab, Utah.

Page 33 Yokuts painting of a grizzly bear and, quite possibly, a bear shaman, one of the most powerful and dangerous members of Yokuts society. Motifs are in red, yellow, and white. A wavy line, or snake, appears to the left. The snake figure may represent a rattlesnake, a guardian of the entrance to the supernatural realm, here symbolized by the cave itself. Late 1800s. Southern Sierra Nevada, California.

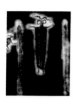 Page 34 A nighttime detail of a Barrier Canyon–style shaman figure with skeletal aspects and a snake (a probable spirit helper) above his head. See page 78 for full image.

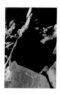 Page 35 A spiral with zigzag on talus boulders is possibly a stylized rendition of a snake. Little Colorado River Anasazi. 1000–1300. Petrified Forest, Arizona.

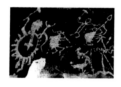 Page 36 Pueblo ceremonial participants include a shield bearer holding a war club in one hand and a two-horned snake in the other, a humpbacked flute player, and an arrow swallower. These figures are pecked into a soot-blackened ceiling of a room excavated in the tuff cliffs of the Pajarito Plateau. 1325–1525. Northern New Mexico.

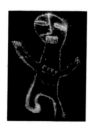 Page 37 Over three feet tall, a masked Pueblo bear, possibly representing a bear shaman, displays a paw print on its abdomen. Rio Grande style. 1325–1680. Petroglyph National Monument, Albuquerque, New Mexico.

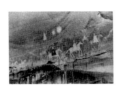

Page 38-39 This documentary rock painting depicts the entrance of the armed Spanish Narbona party into the canyons in 1805. The invasion led to killings in "Massacre Cave." Numerous paintings in the canyon depict a similar theme and provide a constant reminder to the Navajos of this tragic event. Early 1800s. Canyon del Muerto, Arizona.

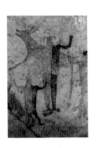

Page 40 Larger-than-life-sized paintings in red and black and outlined in white feature a deer superimposed by shamanic anthropomorphs with uplifted arms. "Diving" figures above the shoulders and small animals at the foot of the large human forms may be spirit helpers. The figure on the right is pierced by arrows. Comondu culture. Estimated dates fall between 580–1500. Flechas Cave, Baja, California.

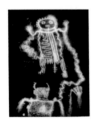

Page 42 Dinwoody or Interior Line–style ceremonial figure. The dots around the head and wavy lines coming from the elbows may represent supernatural power. The line on the right is connected to the shoulder of the figure below. 1000 B.C.– A.D. 1000. Dinwoody, Wyoming.

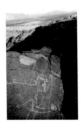

Page 43 A large, nearly life-sized human figure in an animal pose is delineated in outline on a desert boulder in southwestern New Mexico. Similar images occur on Mimbres ceramics between 1050 and 1150. A second profile sketched in peck marks on the edge of the rock echoes the face of the full figure. Mimbres culture, Jornada style. Southern New Mexico.

 Page 45 This textile design filling an entire rock surface is believed to have its origins in the Trincheras culture. 1150–1450. Caborca, Sonora, Mexico.

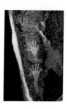 Page 46 Six-fingered hands and arms emerging from a crack. Jornada style, 1050–1400. Three Rivers, New Mexico.

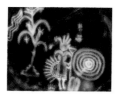 Page 47 Navajo corn in the form of male (crooked) lightning and the Hunchback God, a deified mountain sheep, who is also a god of harvest, of plenty, and of mist. His hump is made of clouds, bordered by a rainbow, and it contains the seeds of all vegetation. He carries a planting stick in his hands. 1680–1750. Northwestern New Mexico.

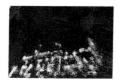 Page 48-49 Historic Ute petroglyphs of horses, bison, bighorn sheep, bear, and other animal tracks, pelts, and people. The broad-shouldered human figures are Ute copies of older petroglyphs in the area, while the bear paws are traditional Ute designs. Late 1800s. Newspaper Rock State Park, southeastern Utah.

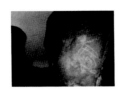

Page 50 Rio Grande–style Pueblo ceremonial figure wearing a tasseled cape and tall headdress of eagle feathers. This figure possibly represents an arrow swallower, a member of a society dedicated to bringing cold snows and winter moisture. The arrow-swallowing rite was also a part of Pueblo war rituals. 1325–1680. Galisteo Basin, New Mexico.

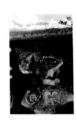

Page 51 A foot and leg merge with unidentifiable Jornada-style animals. Below, on another boulder, a human figure seems to transform into a square or mask element dominated by a symmetrical, horned design. 1050–1400. Three Rivers, New Mexico.

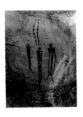

Page 52 Barrier Canyon–style paintings in dark red depict three shamanic figures. Rootlike elements seem to grow out of the feet of the figure on the left who holds what appear to be plants. Flora as well as fauna functioned as spirit helpers in shamanic beliefs. Circa 4000–500 B.C. Central Utah.

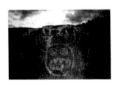

Page 53 A giant, horned mask representing a Pueblo ogre or possibly a warrior, guard, or whipper kachina. Rio Grande style, 1325–1680. Galisteo Basin, New Mexico.

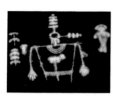

Page 54 San Juan Basketmaker shaman with necklace, fringed sash, and an animal pecked on his chest. Elements projecting from the top of his head and ear may signify supernormal mental and auditory powers. A second smaller figure and stacked crescents appear on either side. 400 B.C. – A.D. 400. San Juan River, Utah.

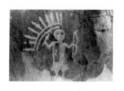

Page 55 Large human torso superimposed over abstract designs on narrow boulder face, Trincheras culture. 800–1400, Caborca, Sonora, Mexico.

Page 56 Navajo supernatural figure with long, feathered headdress carries a bow in his left hand. This figure possibly represents Monster Slayer, the elder twin. 1680–1750. Northwestern New Mexico.

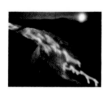

Page 59 Navajo horses pecked across a slab of fallen sandstone. Late 1800s or early 1900s. Bluff, Utah.

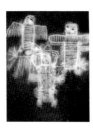

Page 61 Complicated bird elements of the Dinwoody or Interior Line style created by patterns of lines, circles, and dots. The lowest figure appears to be transformational in character with human features such as the face "mask" and perhaps hands as well as wings. The facial areas of the other two figures have been defaced by bullet holes. 1000 B.C.–A.D. 1000. Dinwoody, Wyoming.

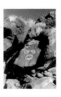

Page 62 A rock displaying a face with a round mouth full of teeth possibly represents Masau, god of death, germination, fire and the Earth's surface. Rio Grande style, 1325–1680. Galisteo Basin, New Mexico.

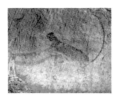

Page 63 These paintings were made by hunter-gatherers who lived near the junction of the Rio Grande and Pecos Rivers in West Texas. A nine-foot-long panther painted in red is the largest of several cats that distinguish the shamanic rock paintings of Panther Cave. Below this feline is a bird shaman in black that rises above a circle. The latter may symbolize the passage between worlds. Pecos River style, 2000–1000 B.C. Seminole Canyon, Texas.

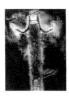

Page 64 Panther shaman with cat ears, holding atlatl and darts. Pecos River style, 2000–1000 B.C. Panther Cave, Seminole Canyon, Texas.

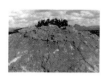 Page 65 Square-bodied human figures with faces, a lizard, an outlined cross, a sunburst, and other Jornada-style petroglyphs that could be Mimbres in origin. One of the human figures holds a snake or lightning. 1050–1400. Near Cook's Peak, southern New Mexico.

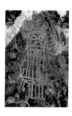 Page 66 Painted in the Interior Line or Dinwoody style, this anthropomorphic figure has an animal superimposed at waist level that may represent a spirit helper. Estimated dates range from early Plains Archaic to Proto-historic period, 1000 B.C.–A.D. 1000. Dinwoody, Wyoming.

 Page 67 Horned shaman with mountain sheep. A smaller animal can be seen inside the sheep. Fremont culture. 700–1250. Northeastern Utah.

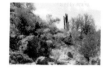 Page 68-69 Parallel zigzags and sunburst petroglyphs and saguaro. Caborca, Sonora, Mexico.

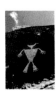

Page 70 Shaman with duck on his head. This common motif in late Basketmaker rock art is believed to symbolize shamanic flight. In the Pueblo world, the duck is still regarded as a vehicle of supernatural travel. Late San Juan Basketmaker, 200–600. San Juan River region, Utah.

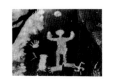

Page 72 Little Colorado Anasazi petroglyphs featuring a human figure and textile motifs. 1000–1350. Petrified Forest National Park, Arizona.

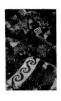

Page 74 Interlocking scrolls, Trincheras culture. 1150–1450. Caborca, Sonora, Mexico.

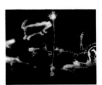

Page 75 Petroglyphs of unidentifiable animals, a human figure, and an ascending anthropomorphic form with large eyes comprise a seemingly shamanic scene. It is possible that this group was created by a shamanic practitioner to describe his supernatural journey. Anthropomorphic elements resemble those in the Barrier Canyon style, thereby suggesting that they are pre-Fremont in age, or made before circa A.D. 500, Central Utah.

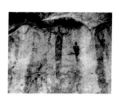

Page 77 Illuminated detail of the upper portion of a red shaman with a pantherlike head, holding sticks and various other objects, Pecos River style, 2000–1000 B.C. Panther Cave, Seminole Canyon, Texas.

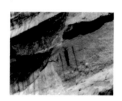

Page 78 Painted in dark red, the life forms surrounding the Barrier Canyon–style shaman figure lack obvious natural counterparts. Painted by hunter-gatherers of the Western Archaic tradition, Barrier Canyon–style paintings date from approximately 4000–500 B.C. Central Utah.

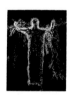

Page 79 (detail) Full elongated figure of the red shaman on page 78. He is flanked by smaller shamans (lower left) and sets of parallel lines. Wavy lines crossing the body resemble snakes.

Page 81 San Juan Basketmaker figure, probably depicting a shaman, with birds in close association. In addition there are two large lobed circles faintly visible on the right. On the left, a staff is surmounted by a crescent of unknown significance. Similar crescents play a significant role as headdresses in other Basketmaker rock art. Wolf or other canine prints occur at either side. 400 B.C.– A.D. 400. Bluff, Utah.

SUGGESTED READING

Cole, Sally J. *Legacy on Stone: Rock Art of the Colorado Plateau and the Four Corners Region.*
Boulder, CO: Johnson Books, 1990.

Conway, Thor. *Painted Dreams: Native American Rock Art.*
Minocqua, WI: Northword Press, Inc., 1993.

Schaafsma, Polly. *Indian Rock Art of the Southwest.*
Santa Fe and Albuquerque, NM: School of American Research and University of New Mexico Press, 1980.

———. *Rock Art in New Mexico.*
Santa Fe, NM: Museum of New Mexico Press, 1992.

Turpin, Solveig A., ed. *Shamanism and Rock Art in North America.* Special Publication, No. 1.
San Antonio, TX: Rock Art Foundation, Inc., 1994.